HOT GUYS *and* BABY ANIMALS

Audrey Khuner *and* Carolyn Newman
Photography by Eliot Khuner

Andrews McMeel Publishing, LLC

Kansas City • Sydney • London

Andrews McMeel Publishing, LLC
an Andrews McMeel Universal company
1130 Walnut Street, Kansas City, Missouri 64106

www.andrewsmcmeel.com

12 13 14 15 WKT 10 9

ISBN: 978-1-4494-0790-2

Library of Congress Control Number: 2011926185

www.hotguysandbabyanimals.com
Photography by Eliot Khuner

Attention: Schools and Businesses

Andrews McMeel books are available at quantity discounts
with bulk purchase for educational, business, or sales
promotional use. For information, please e-mail the
Andrews McMeel Publishing Special Sales Department:
specialsales@amuniversal.com

HOT GUYS *and* BABY ANIMALS

TODD
and BAILEY

Todd likes to go sailing on weekends.

Bailey helps him look for a first mate.

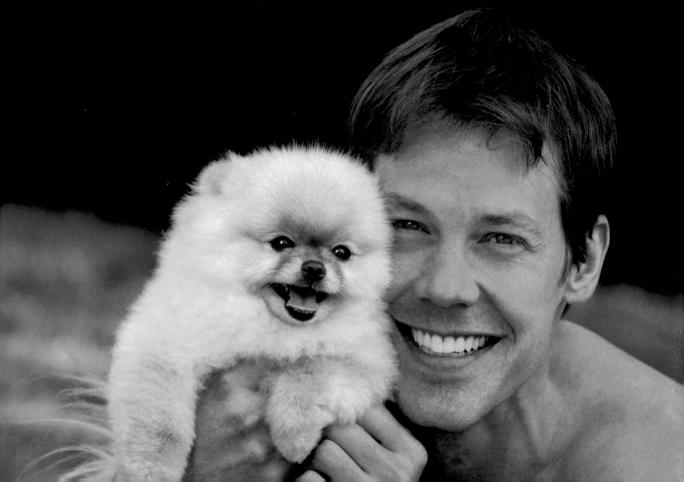

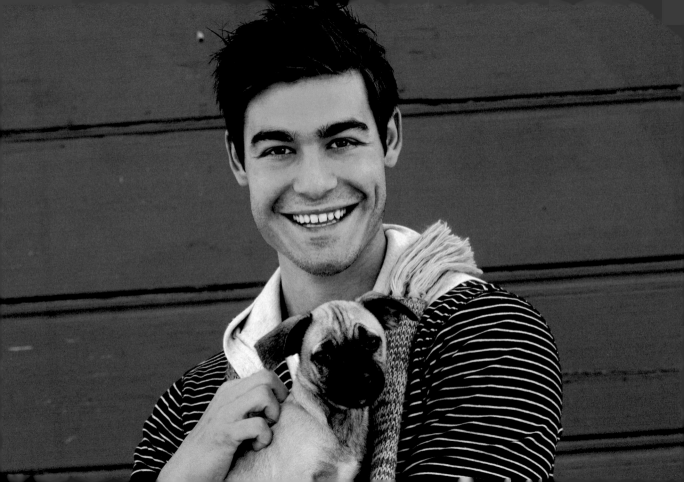

JACOB
and HAZEL

Jacob and his friends own an RV that they call *The Purchase*.

Hazel owns a rug she calls *The Bathroom*.

ADAM
and MINKY

Adam just told Minky he loves her.

Minky isn't sure she's ready to commit.

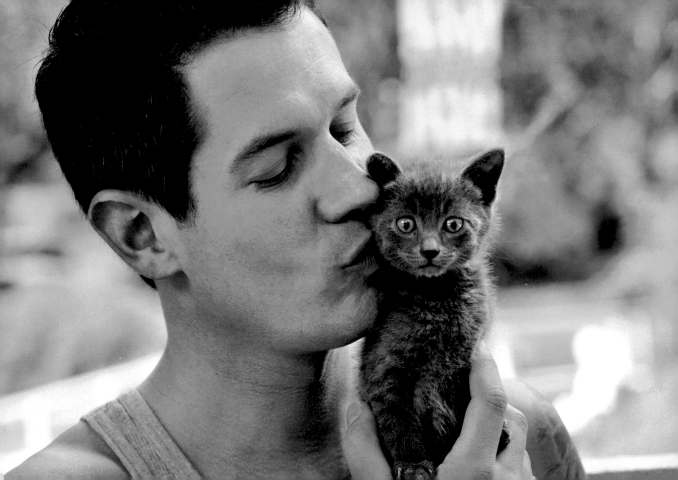

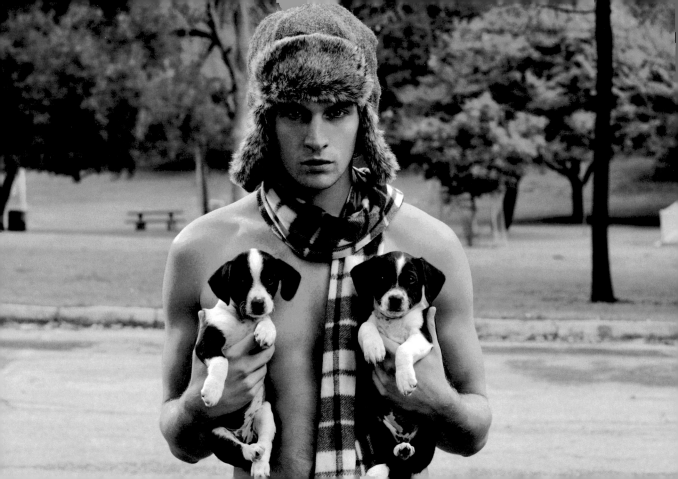

DAVID, MORK, *and* MINDY

David is comfy in just a hat and scarf.

Mork and Mindy are nudists.

CHRISTOPHER and RYAN

Christopher likes to play the mandolin.

Ryan likes to play duck, duck, goose.

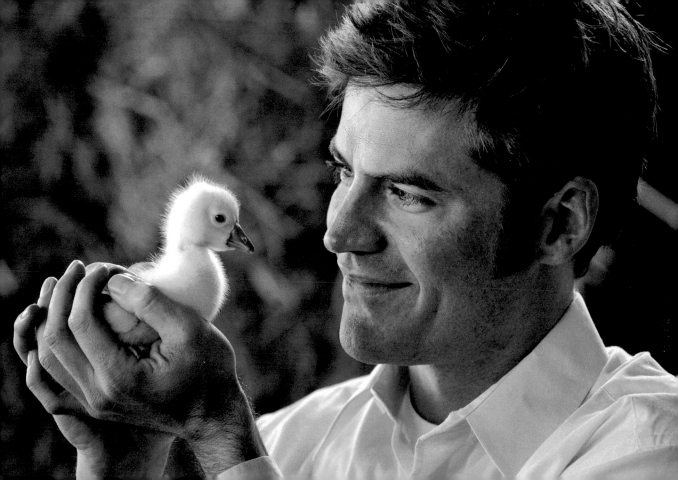

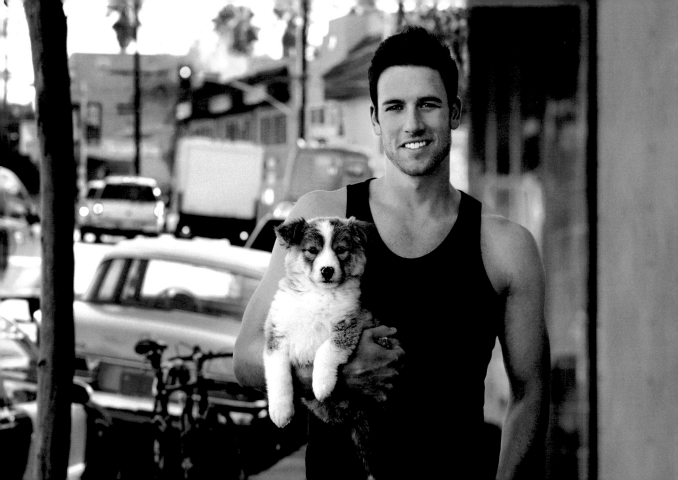

ERIC *and* CHEYENNE

Eric's friends describe him as "happy."

Cheyenne's friends describe her as "destructive."

BILLY RAY
and GEORGIA

Billy Ray used to be a competitive figure skater.

Georgia is a kung fu master.

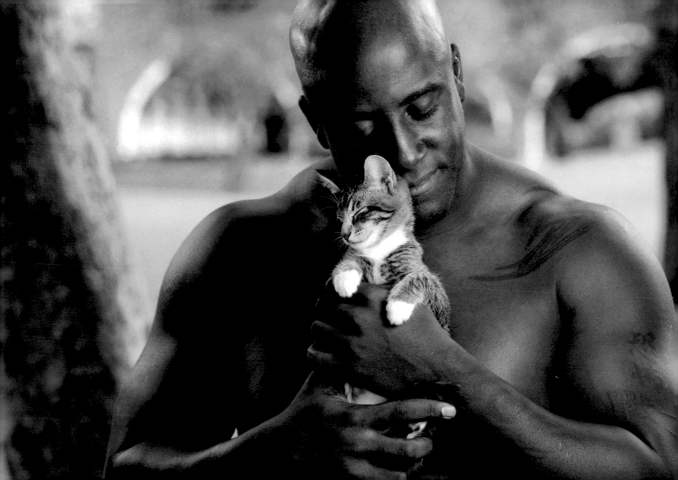

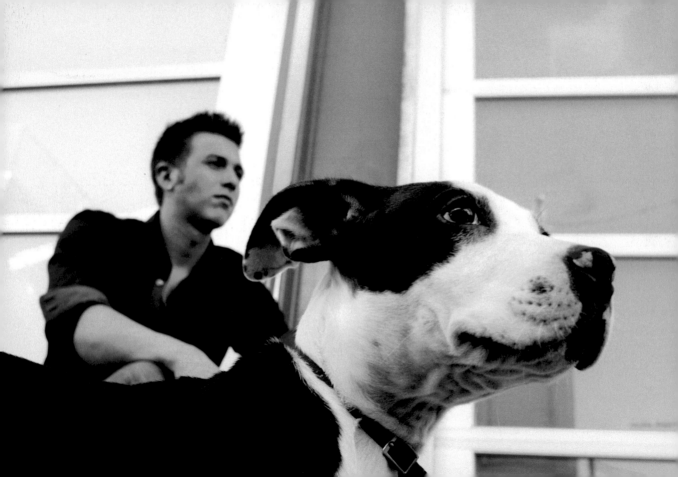

BLAKELY *and* SPORTY

Blakely is from a family of coal miners.

Sporty is from a family of cuddlers.

PATRICIO *and* MINCA

Patricio is really hot.

Minca is really hot, too—damn fur!

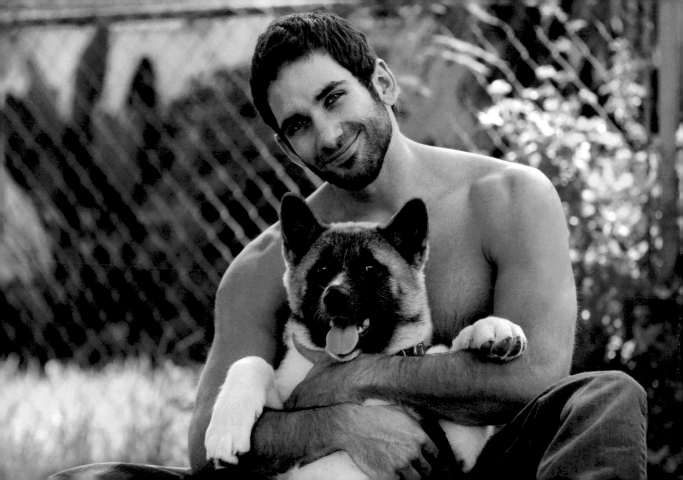

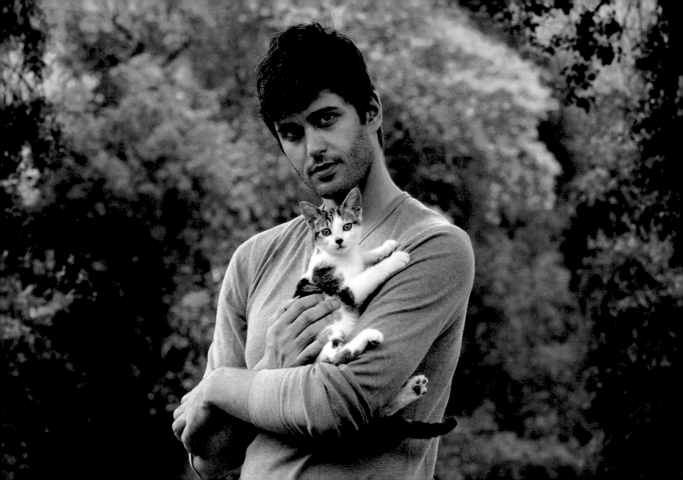

DAVID and ISIS

David plays a superhero at Universal Studios.

Isis understands that with great power comes great responsibility.

FRANK *and* BEOWULF

Frank is a thrill seeker.

Beowulf pees when he gets excited.

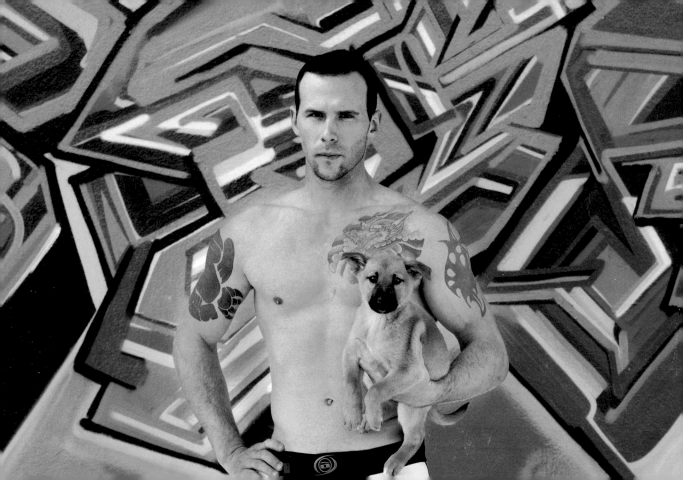

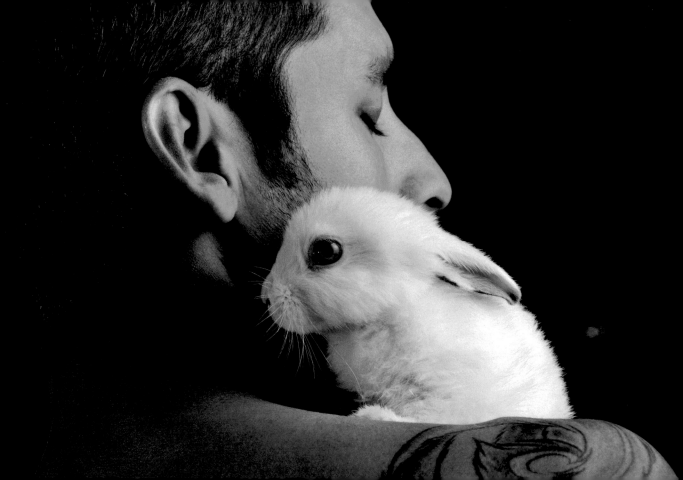

ANTONIO *and* SNOWFLAKE

Antonio likes tattoos.

Snowflake likes to keep her canvas blank.

OLEV
and TOBY

Olev works for a catering business.

Toby does flower arrangements for bar mitzvahs.

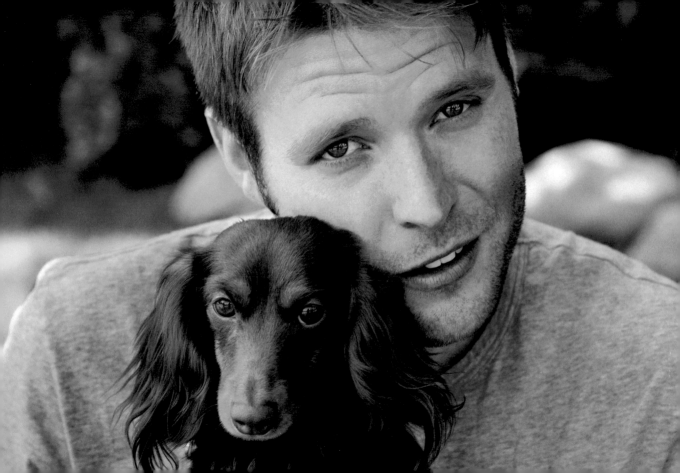

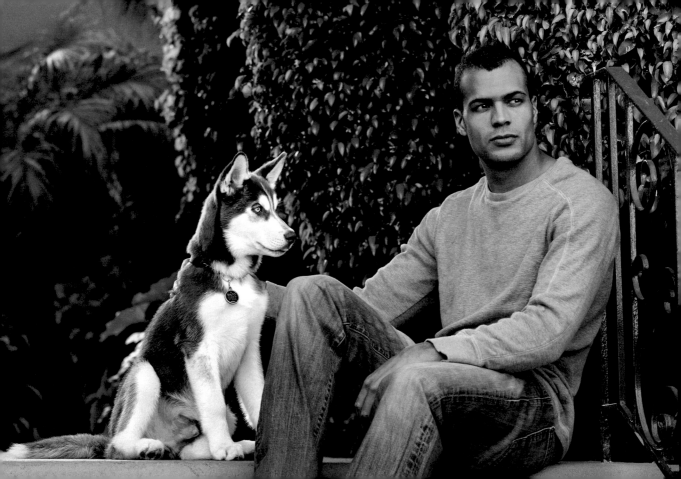

ETHAN and BALTO

Ethan likes them tall and lean.

Balto likes them short and husky.

PAUL and PEARL

Paul likes listening to R&B.

Pearl knows the whole soundtrack from *Beaches*.

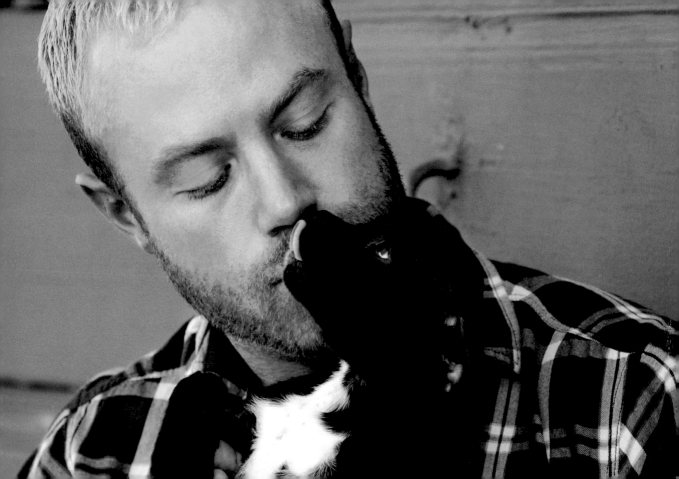

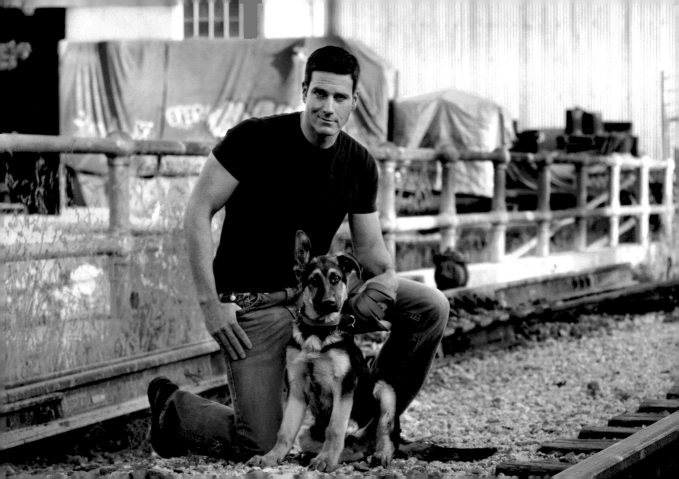

CARL *and* QUENTIN

Carl is a firefighter.

Quentin pees on fire hydrants.

RYAN
and LOLA

Ryan is a mechanic in an auto shop.

Lola likes to stick her head out the car window.

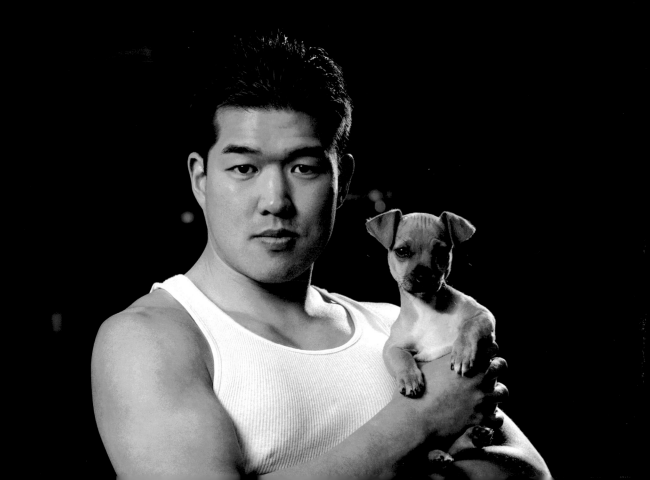

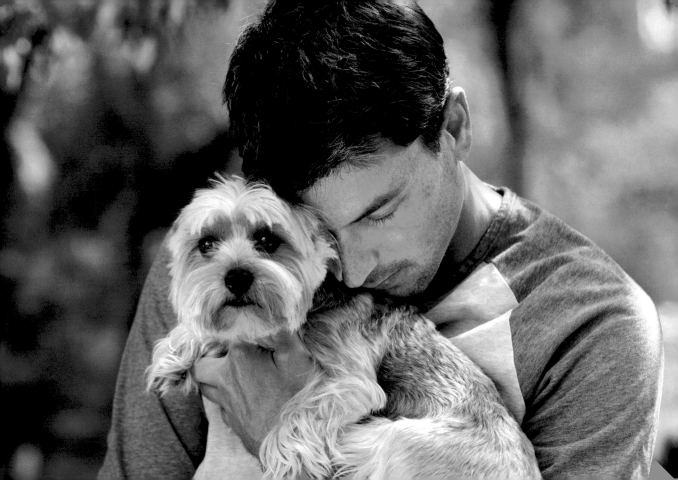

MICHAEL and NED

Michael loves his best friend Ned.

Ned loves cheddar cheese.

ANTHONY and STELLA

Anthony will try anything once.

Stella will eat anything.

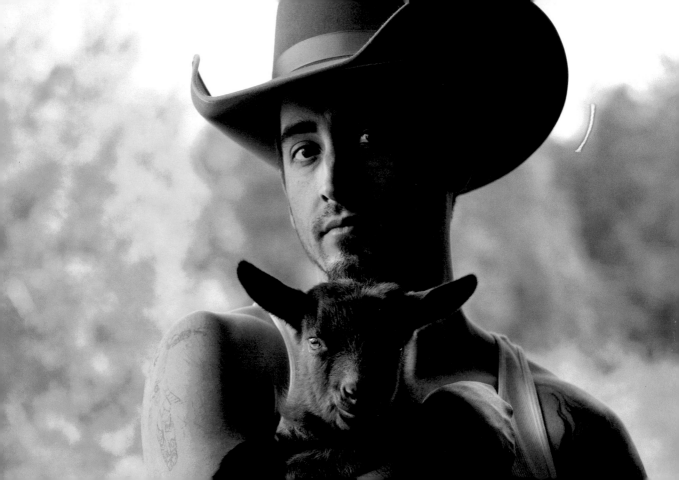

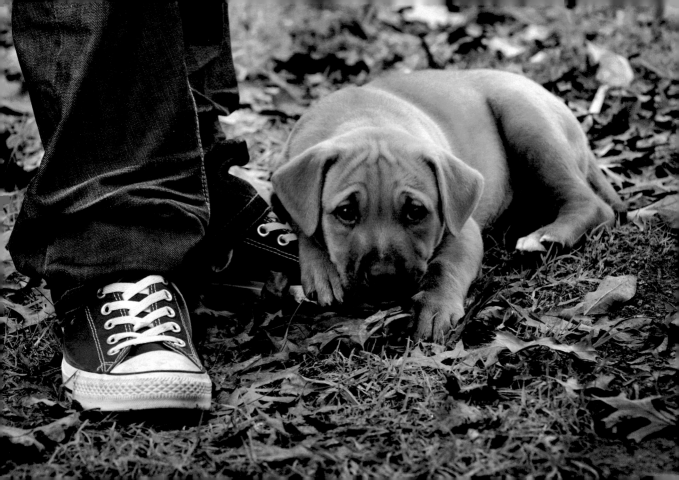

SCOTT *and* POPEYE

Scott is probably annoyed we're only showing his feet.

Popeye thinks it's funny.

BRENT
and MONTY

Brent is looking for a soul mate.

Monty thinks she'll always be Brent's main squeeze.

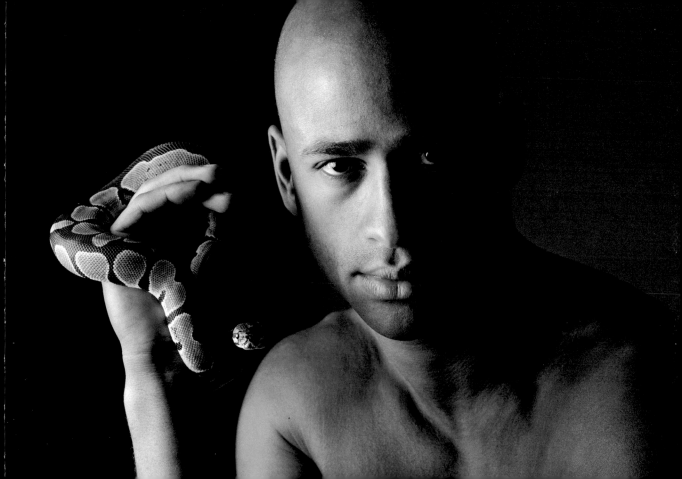

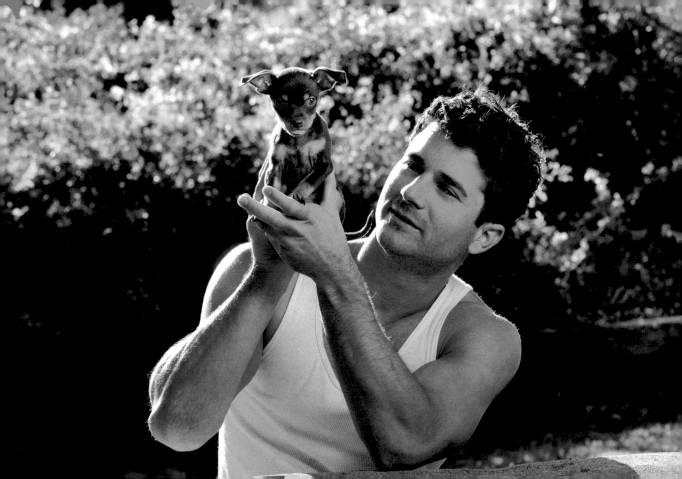

JOHNNY and MR. TRUFFLES

Johnny can't get past how cute Mr. Truffles is.

Mr. Truffles can't get past his name.

MARSHALL and LULU

Marshall is a confident guy.

Lulu is, well, sheepish.

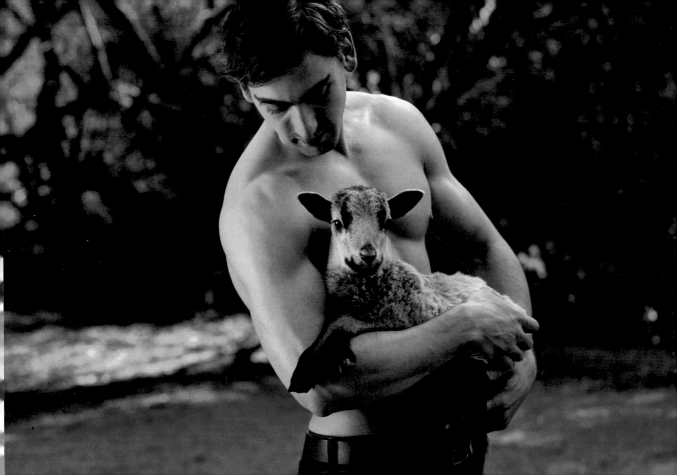

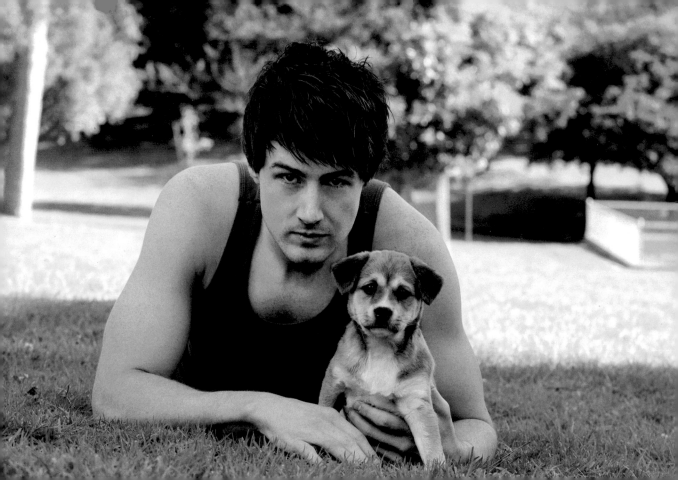

COLE and BOWSER

Cole is an escape artist.

Bowser takes fifty tries to get through the doggie door.

ANDREW, SUZETTE, GIGI, *and* JEAN-LUC

Andrew is great with the chicks.

Suzette, Gigi, and Jean-Luc are even better with the guys.

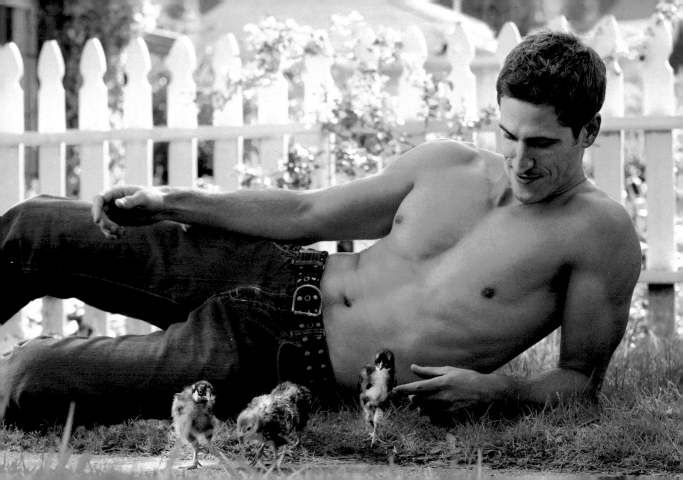

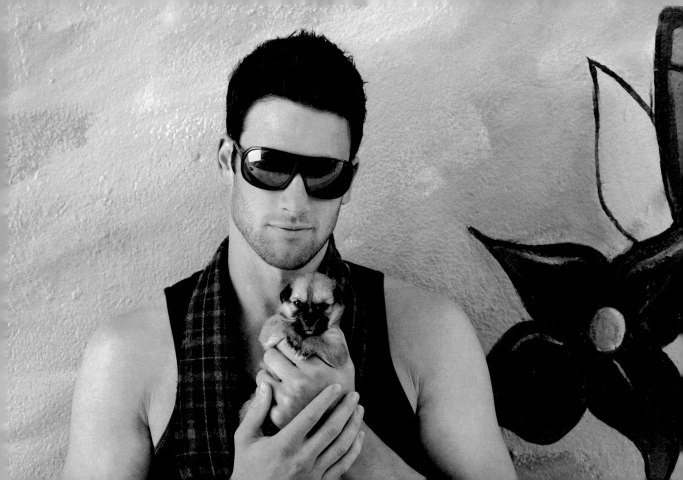

ERIC *and* BABY

Eric likes to dance dirty.

Nobody puts Baby in a corner.

WYATT, JED, and HOLLYWOOD

Wyatt and Jed played with dinosaurs when they were little.

Hollywood chews on bones.

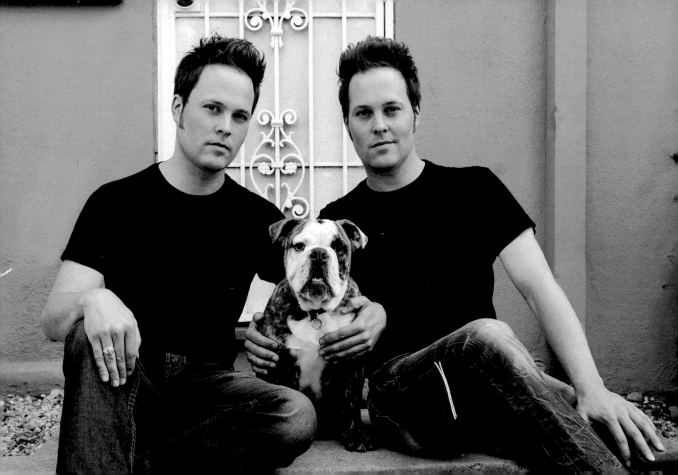

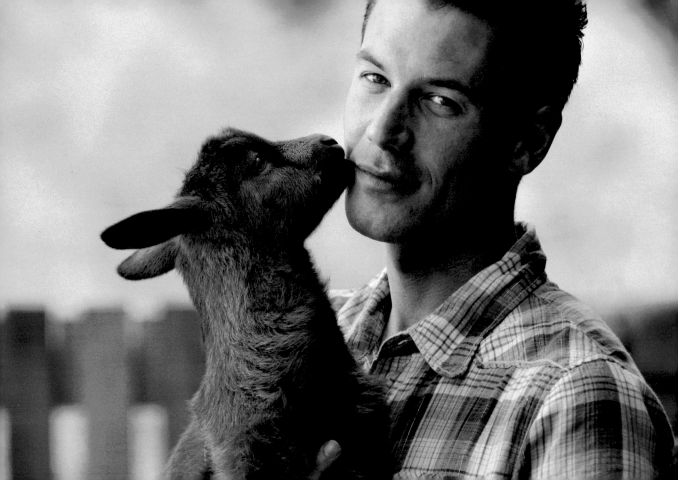

ADAM and GERTIE

Adam was hoping to pose with a puppy.

Gertie was also hoping to pose with a puppy.

MATT
and COLBY

Matt's first word was "turtle."

Colby's first word was "idiosyncratic."

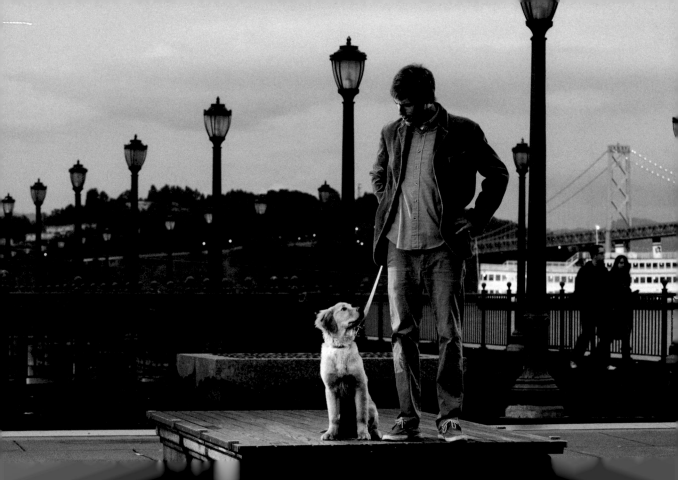

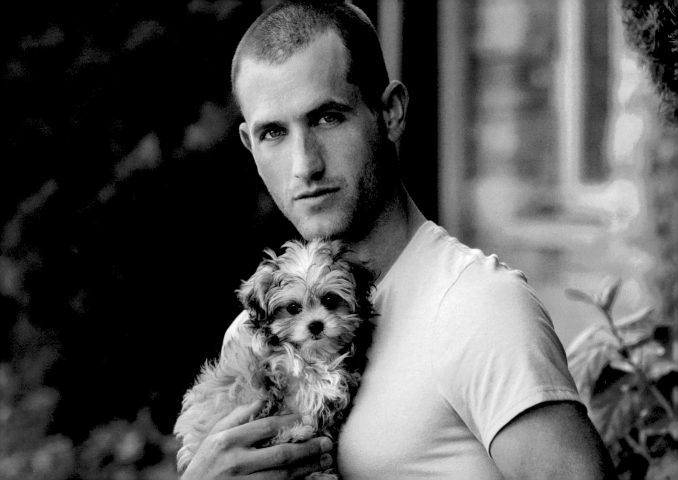

TYLER
and OSLO

Tyler writes his own songs on guitar.

Oslo thought hanging out with Tyler would help him get some play.

HERMAN and QUENTIN

Herman hosts a real estate show called *Habitat for Hermanity*.

Quentin is looking for a one-bedroom doghouse with an ocean view.

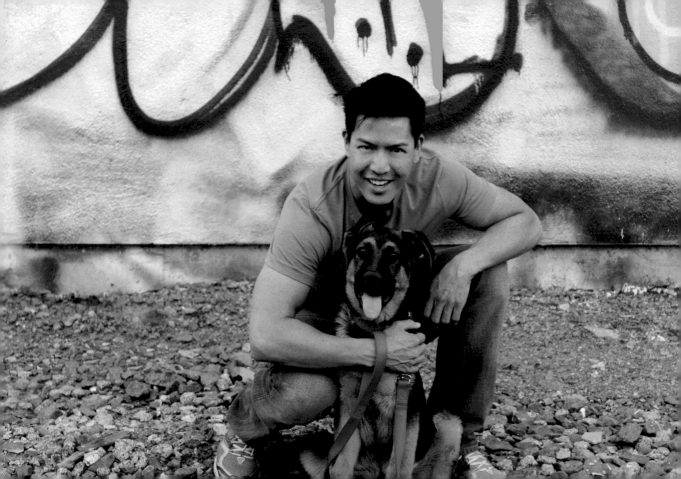

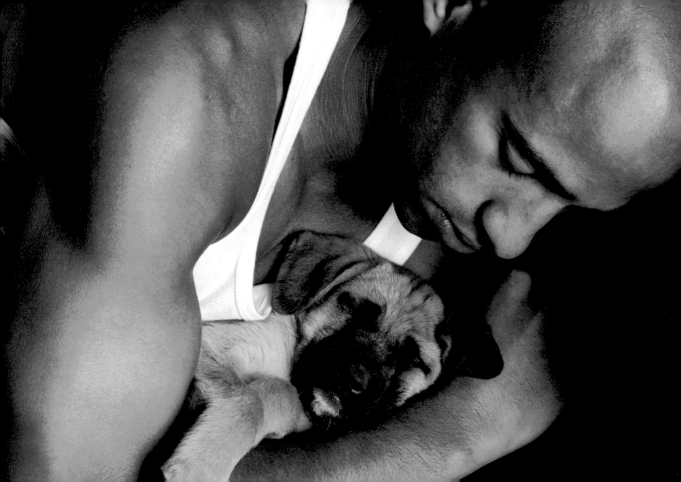

BRENT
and RUFUS

When Brent is awake, he likes to play basketball.

When Rufus is awake, he calls the shots.

MARK and SADIE BELLE

Mark thinks people like him because he has a great smile.

Sadie Belle thinks people like Mark because he has Sadie Belle.

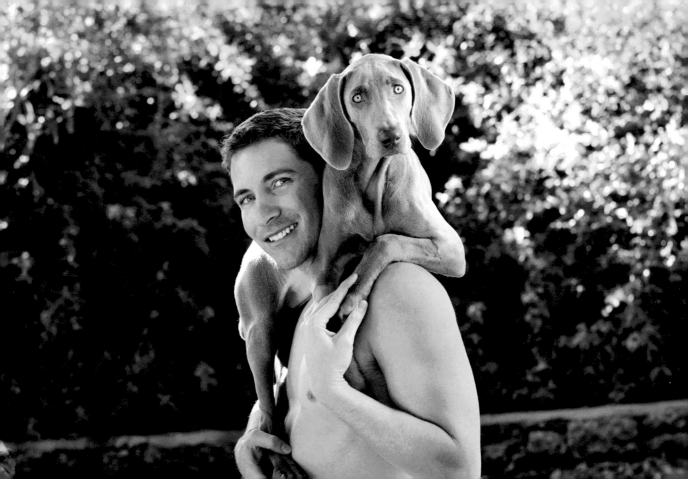

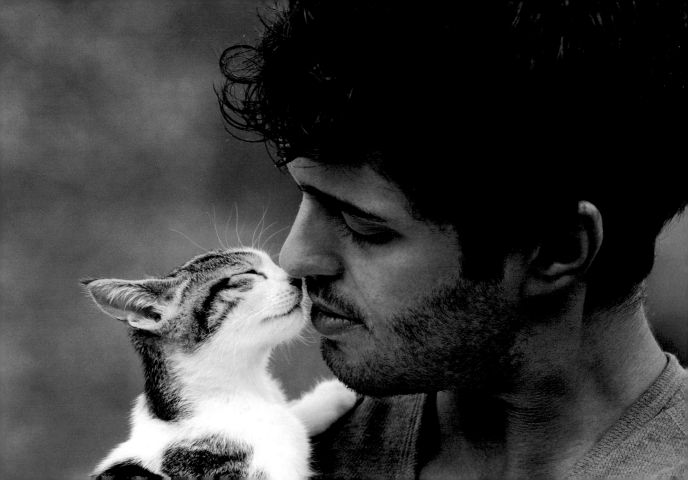

DAVID and ISIS

David likes to talk about his feelings.

Isis likes to purr it out.

THEO *and* CHUCK

If Theo could be any animal, he'd be a puppy.

If Chuck could be any animal, he'd be a hot guy.

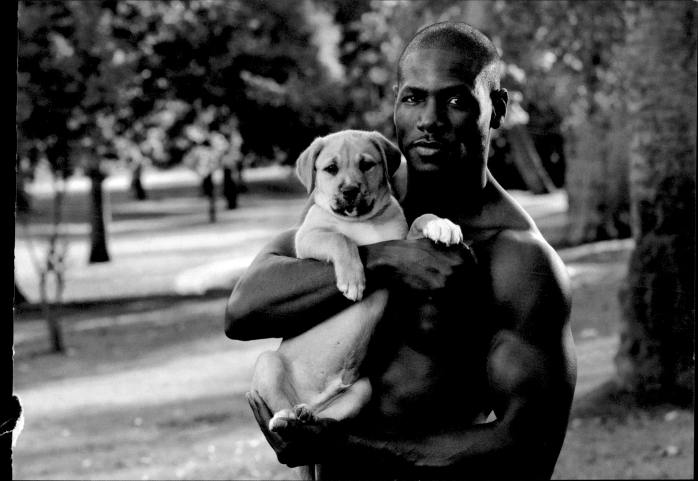

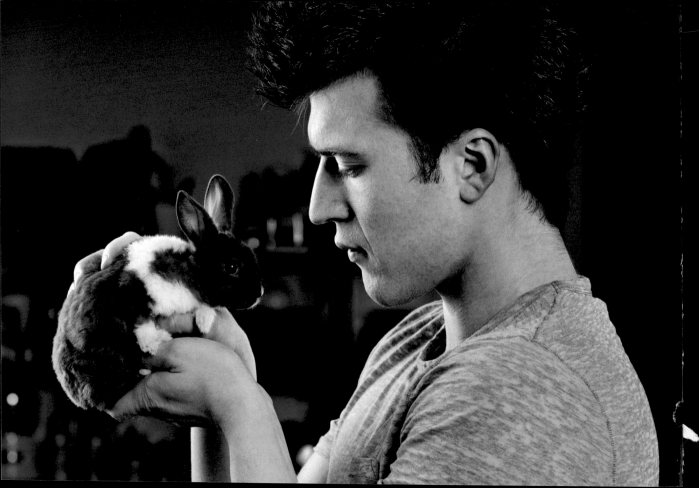

BRUNO
and MOCHA

Bruno works at a PR agency.

Mocha is a shiatsu massage therapist.

BLAKELY, SPORTY, *and* BUTTERSCOTCH

Blakely likes caramel lattes.

Sporty and Butterscotch like toilet water.

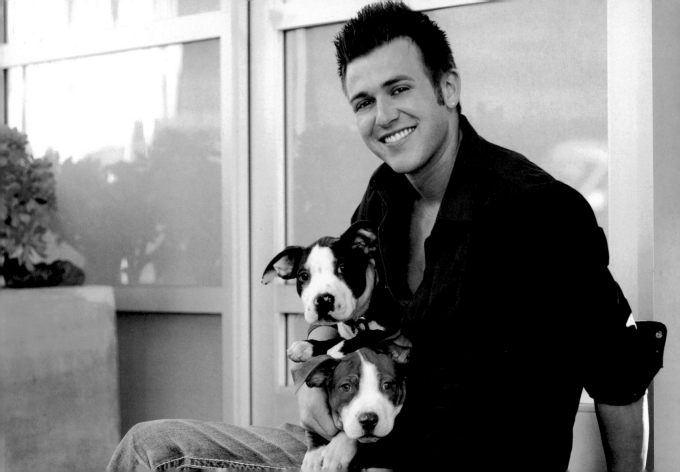

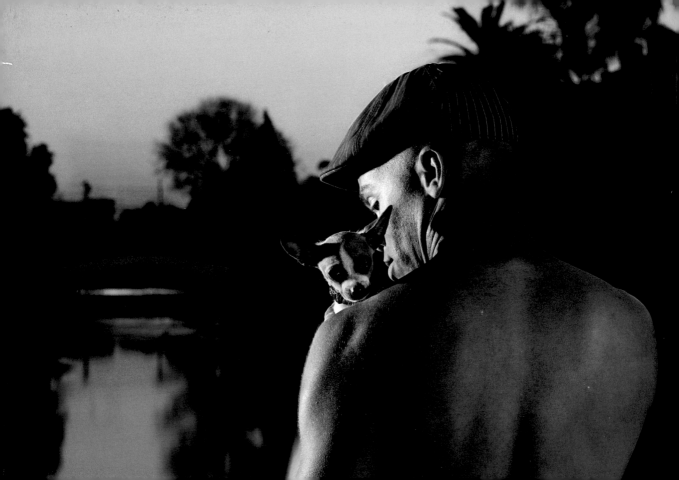

DAVID *and* MR. CHIPS

David likes to watch the sunset after a big day.

Mr. Chips likes to watch the sunset after a big poop.